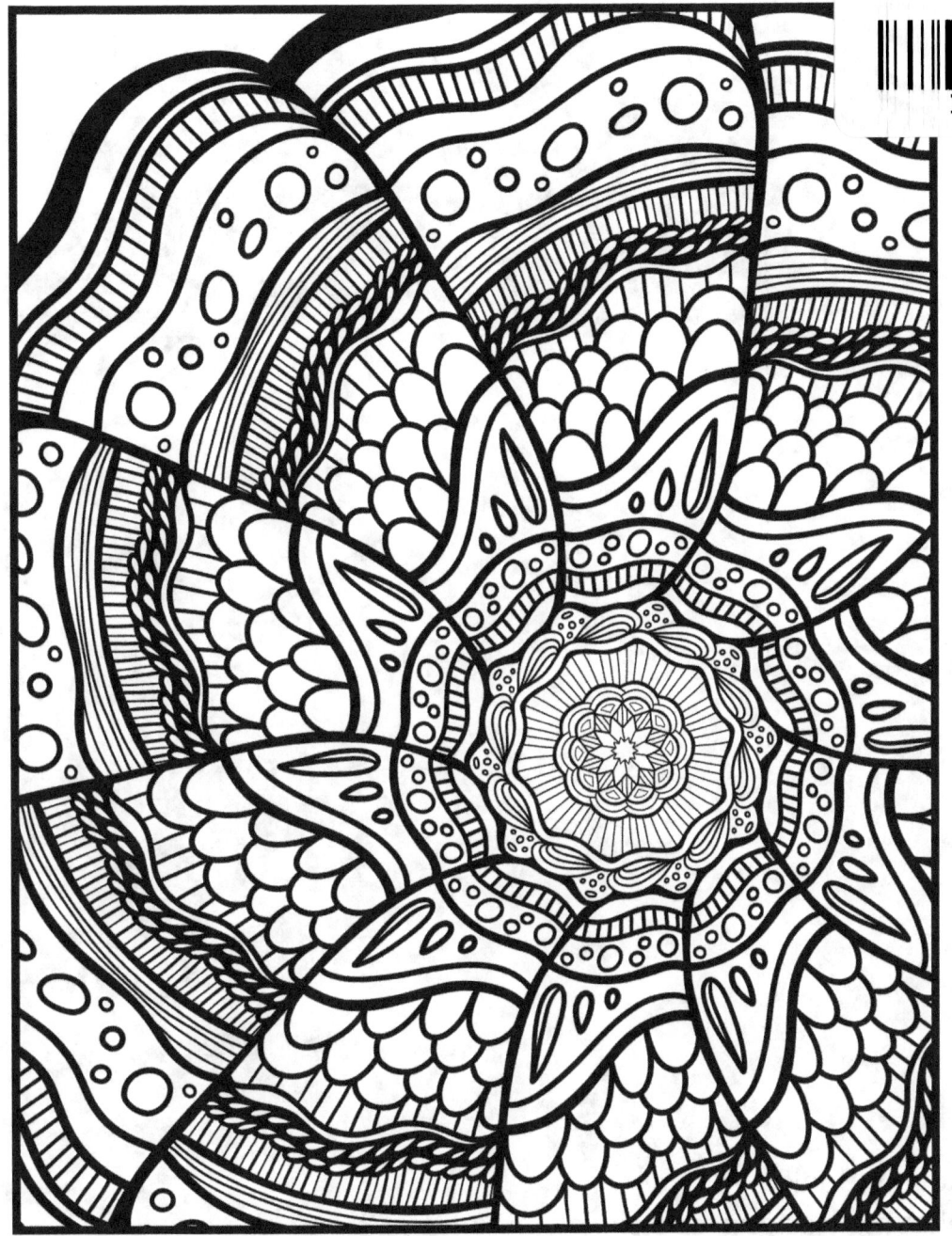

Adult Coloring Book
STRESS RELIEVING DESIGNS FOR RELAXATION
VOLUME 3

Illustrated by

Karalyn Rose

www.karalynrose.com

Adult Coloring Book
Stress Relieving Designs for Relaxation Volume 3
Copyright © Karalyn Rose 2019
All Rights Reserved.
ISBN: 978-1-69102-531-2
www.karalynrose.com

All rights reserved. No part of this book may be reproduced or transmitted in any form or by any means except for your own personal use or for a book review, without written permission from the author.

Thank you for your support!

Welcome Colorists!

The pages in this coloring book were made to provide a variety of stress relieving patterns with a range of complexity depending on your mood. Let yourself relax as you focus your creative energy on adding beautiful colors to the pages and bringing the images to life. Enjoy!

Test your materials on this page. The page behind is intentionally left blank.

Blank pages are intentional.

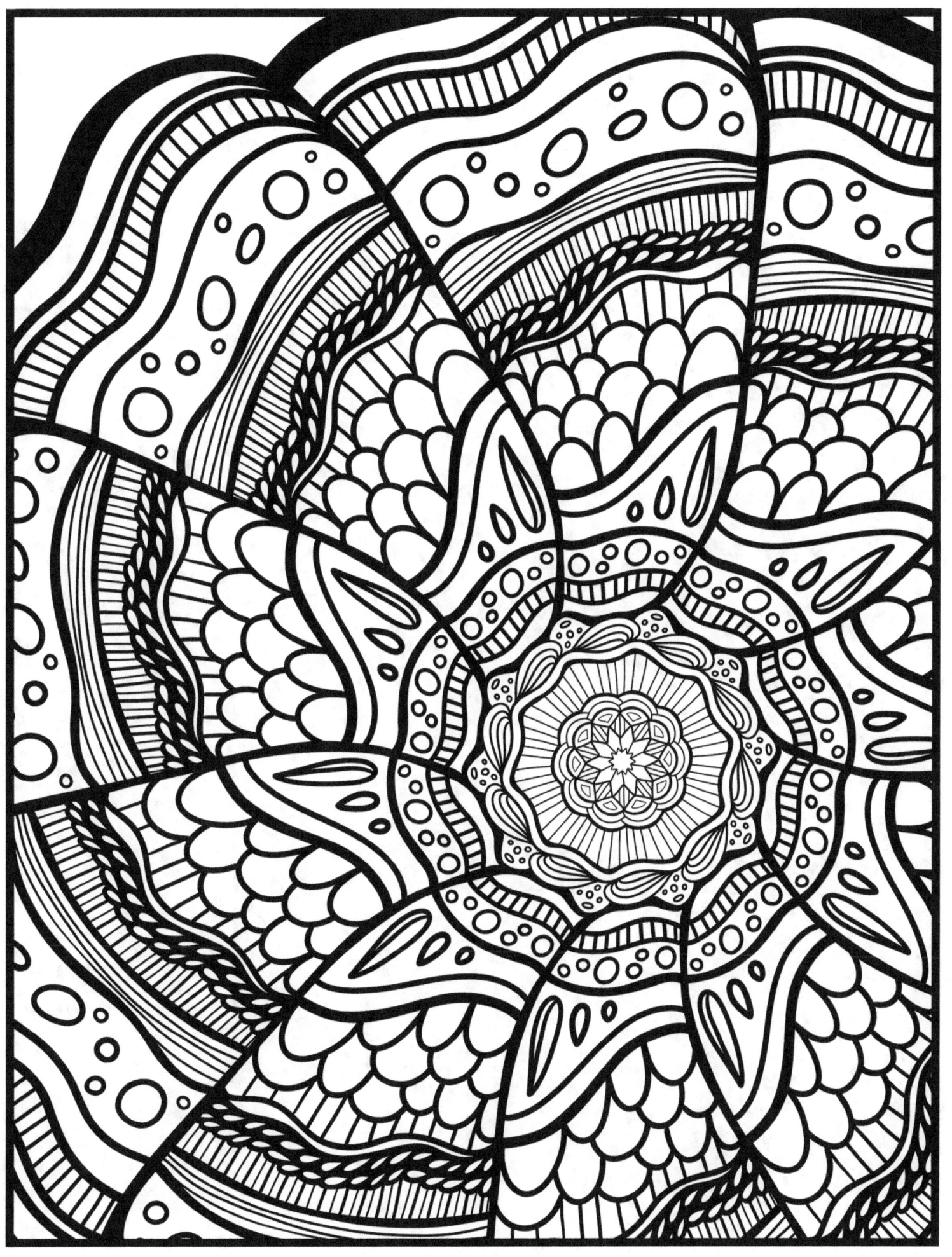

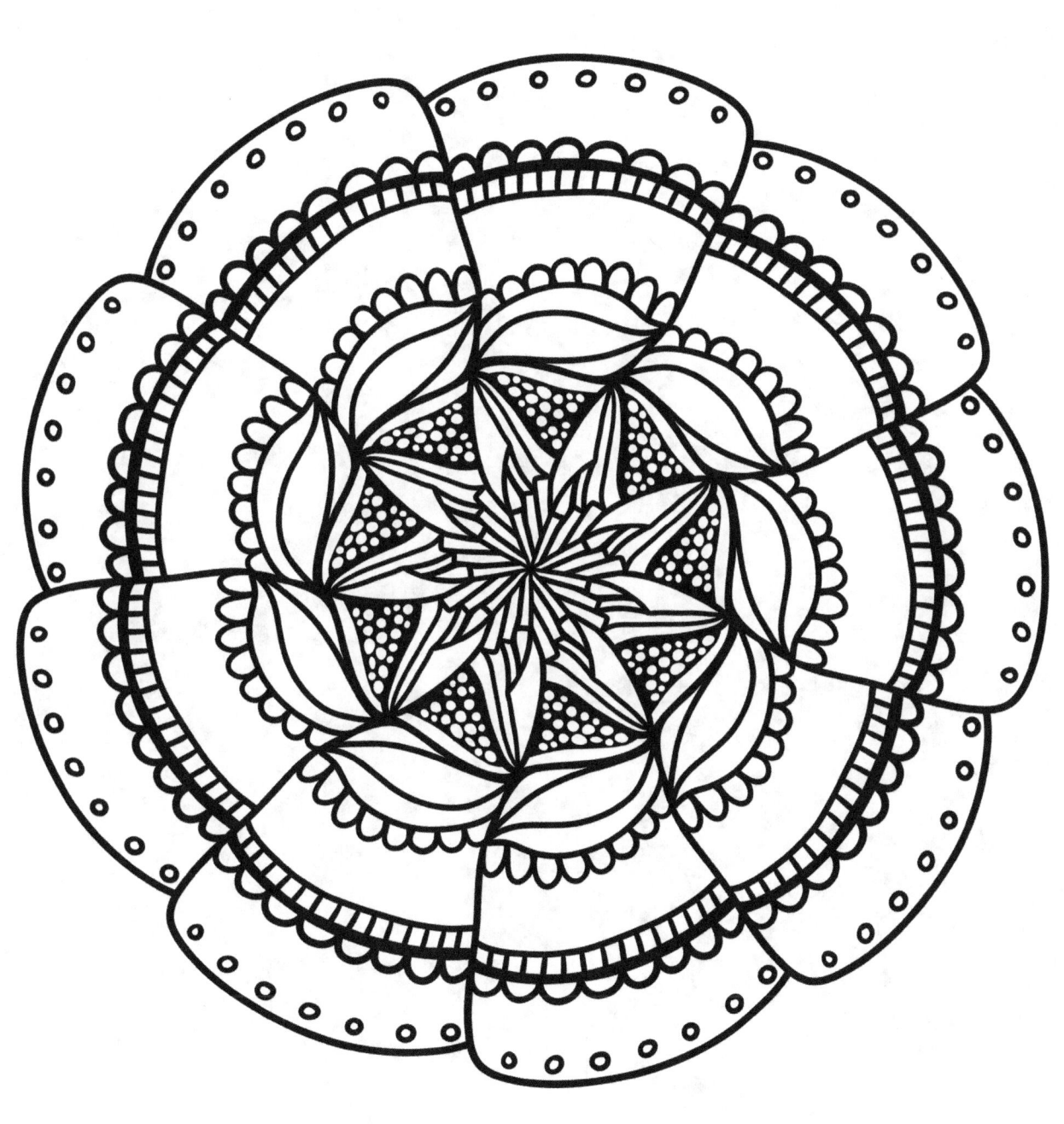

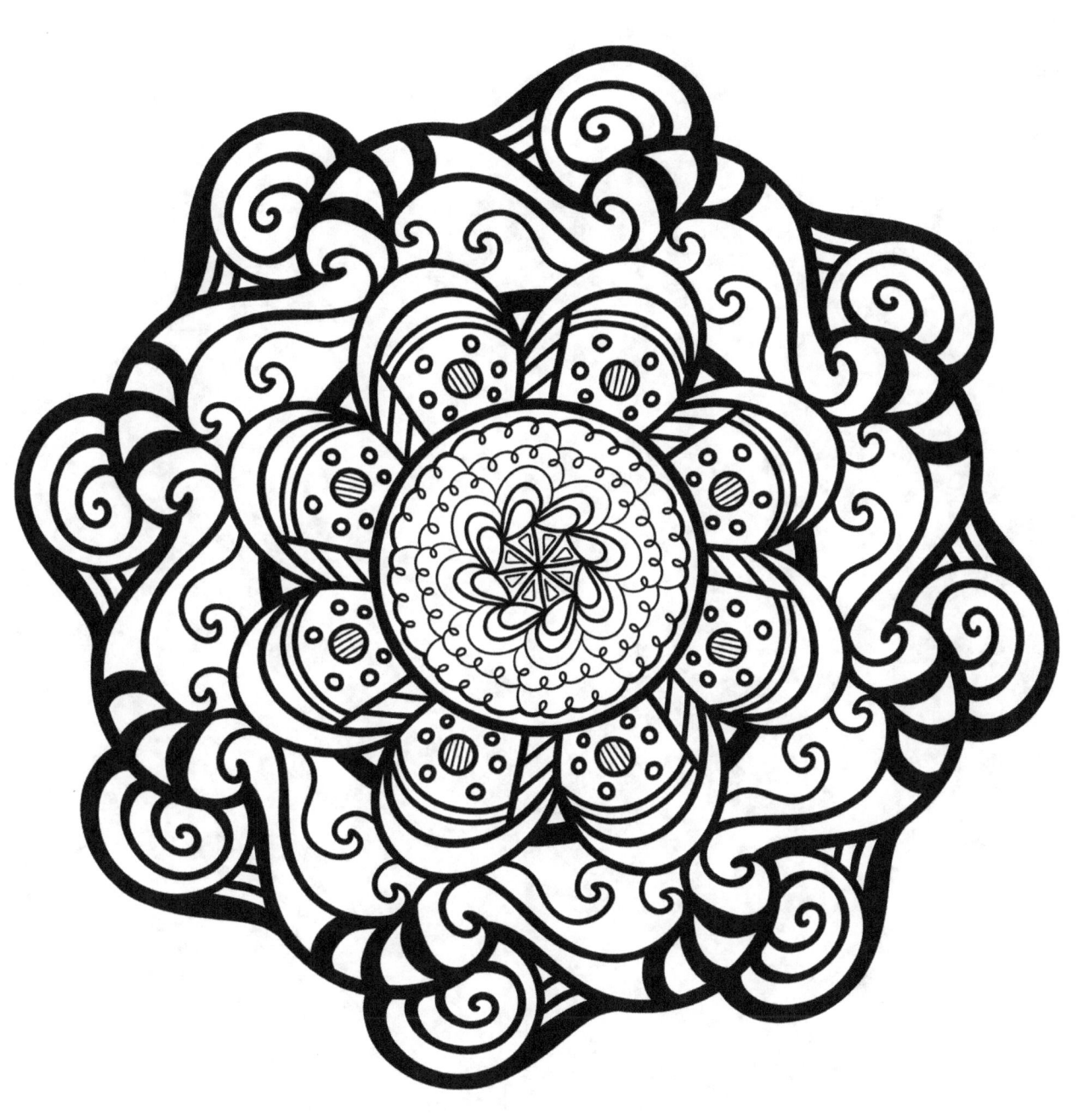

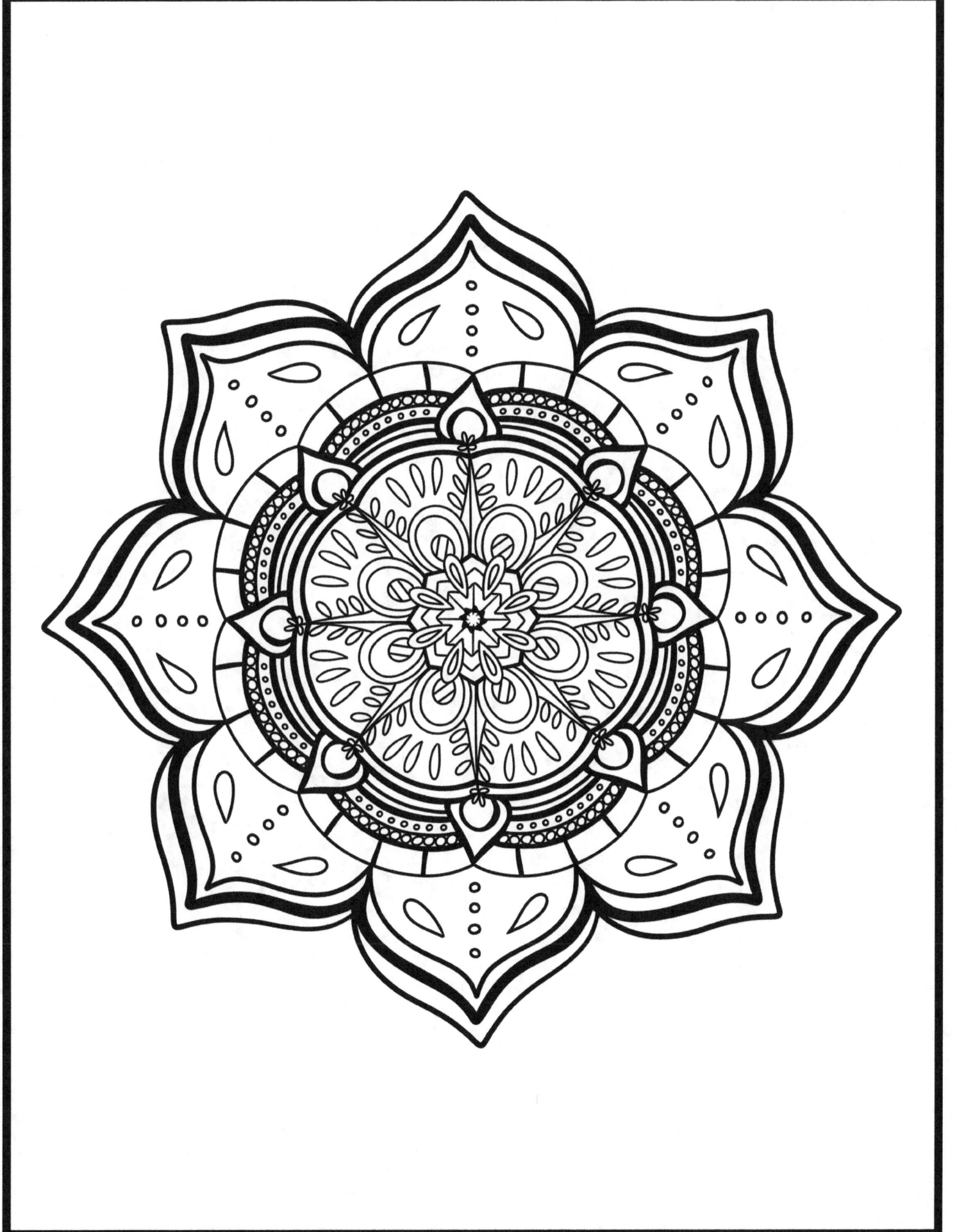

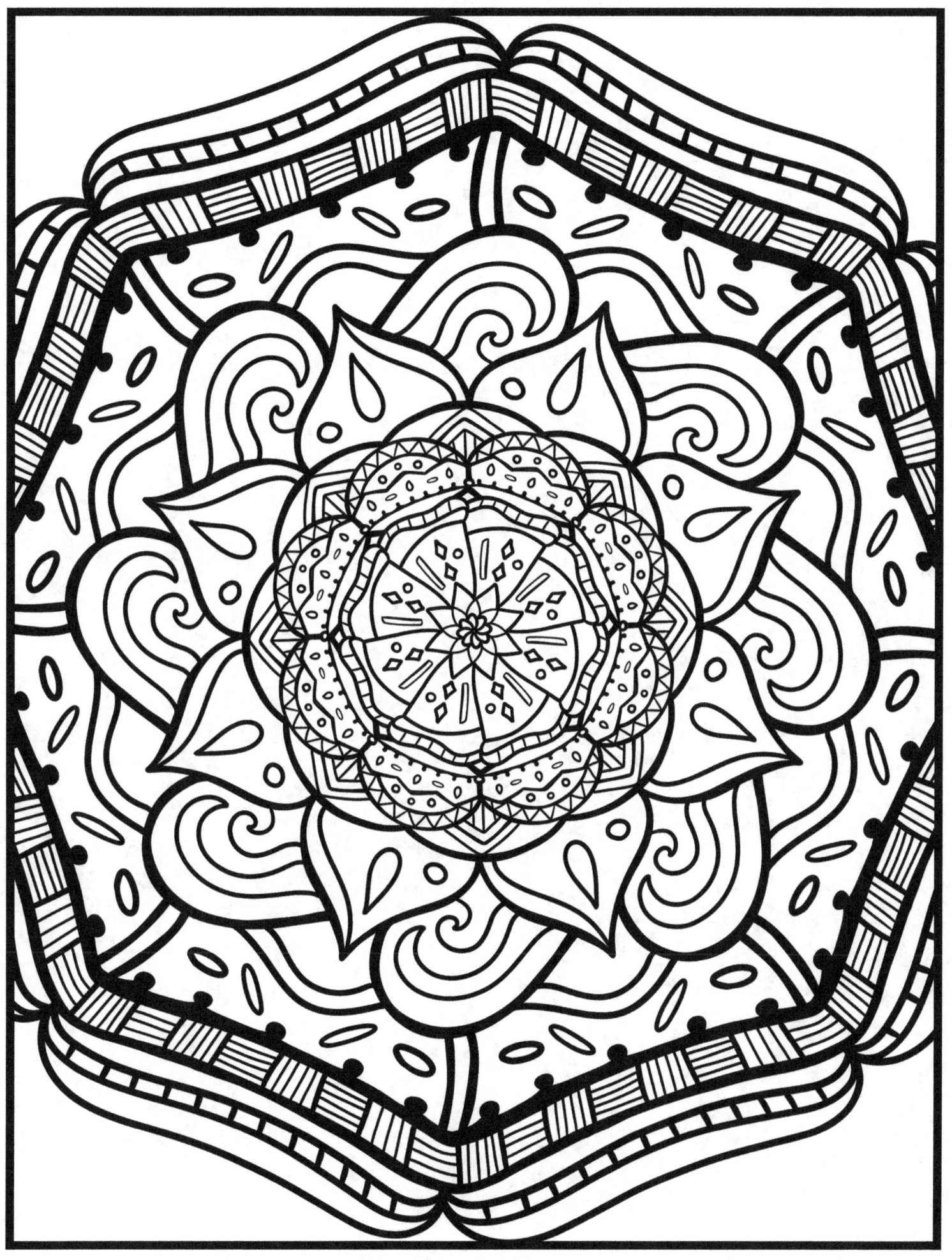

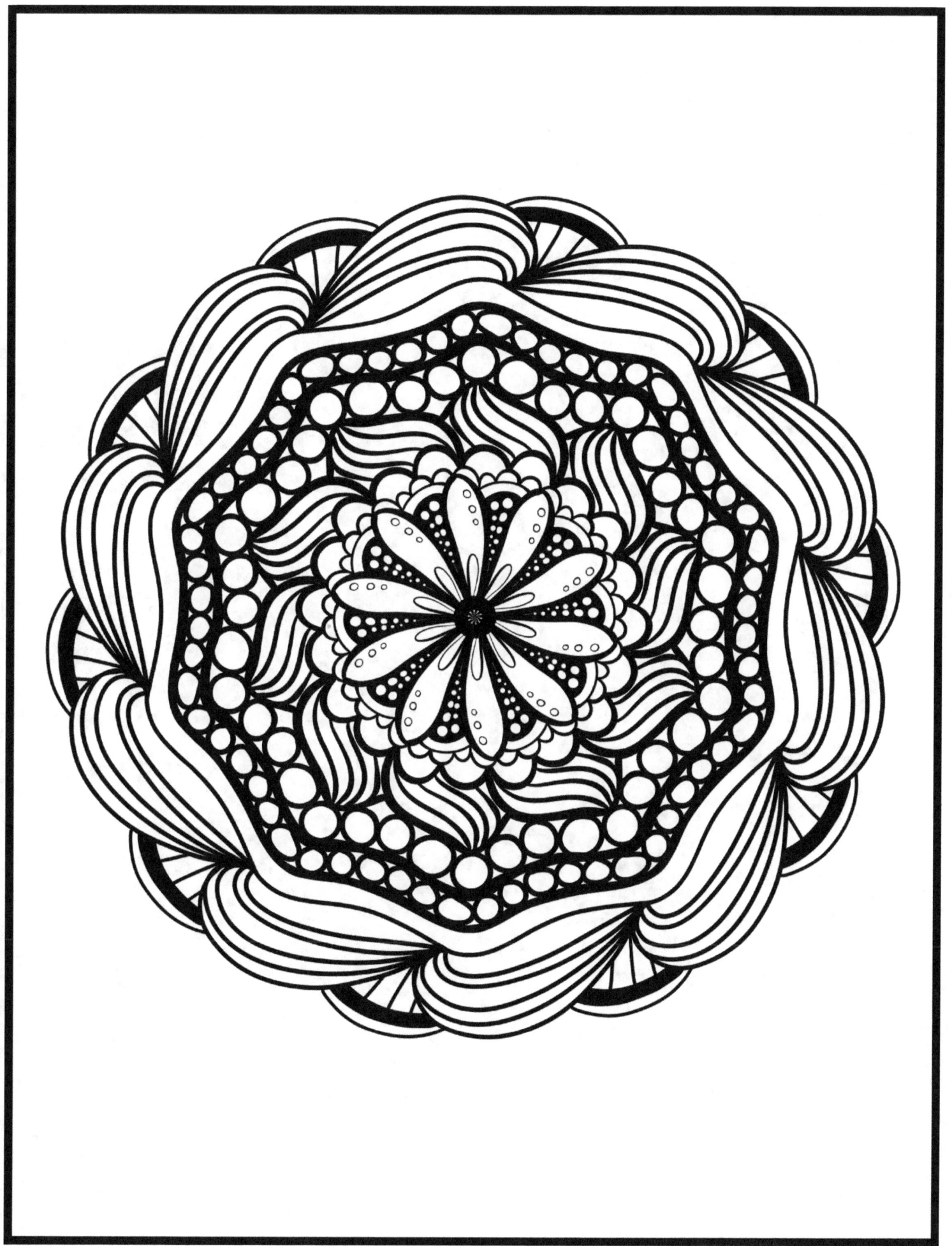

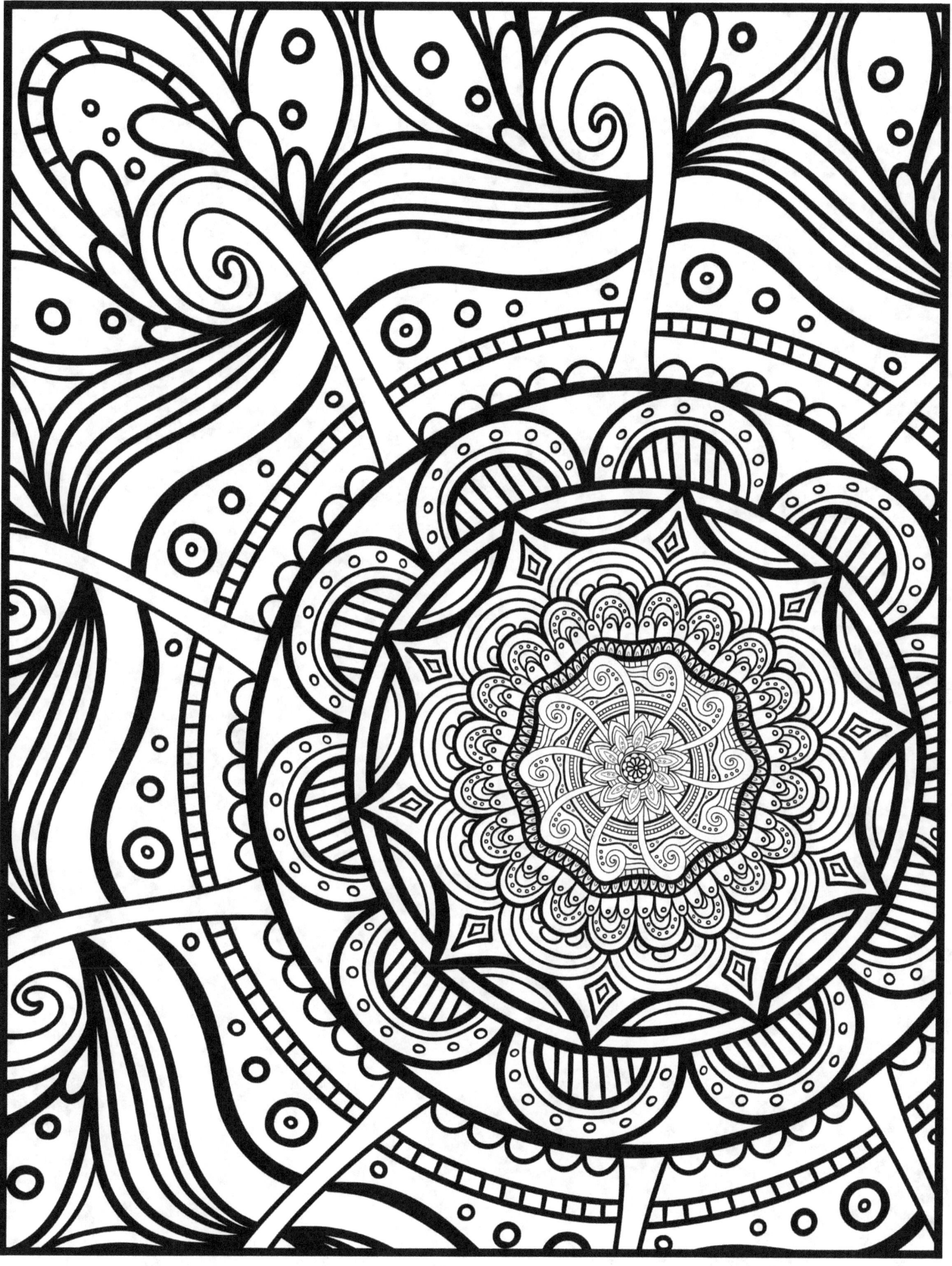

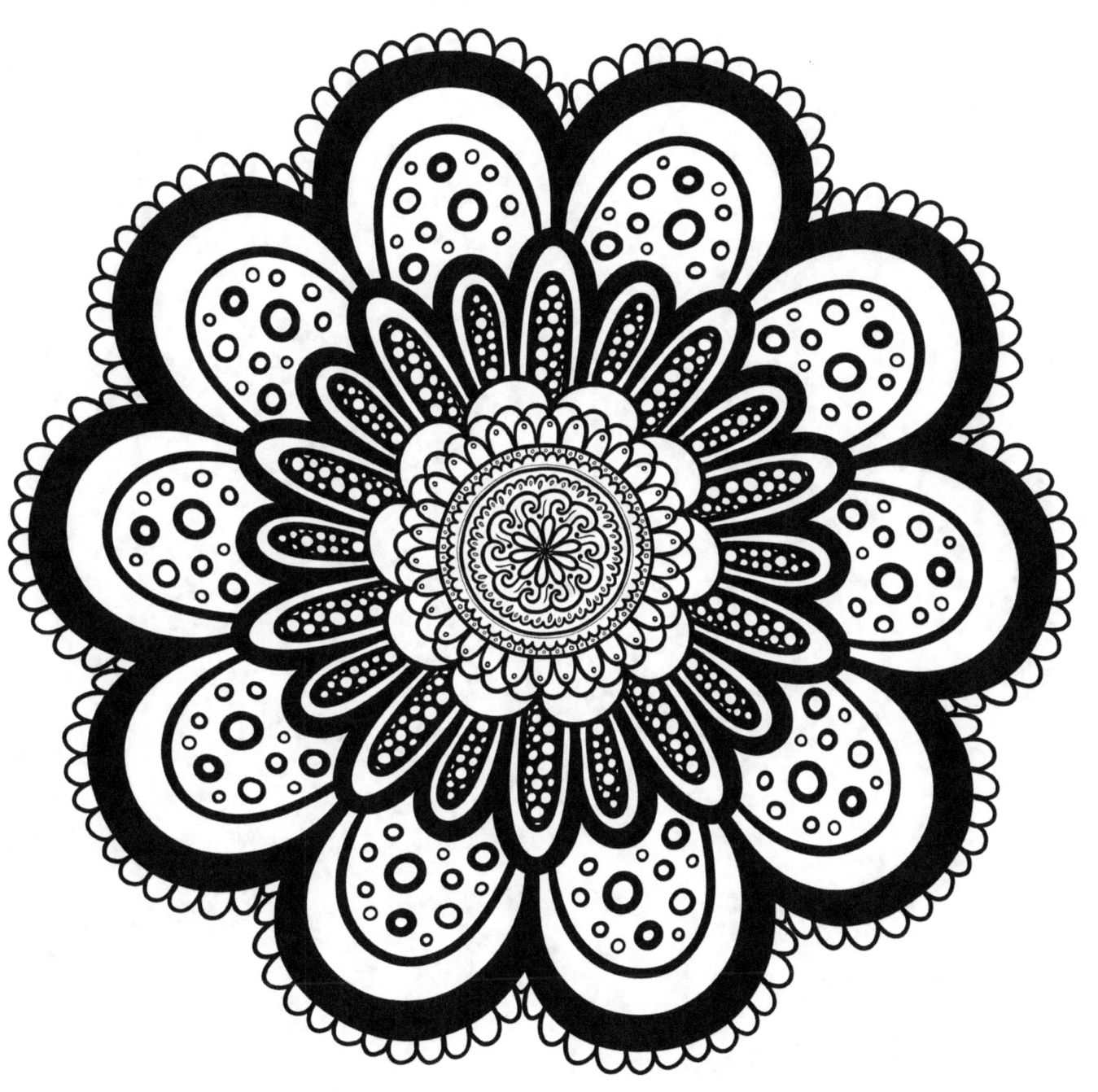

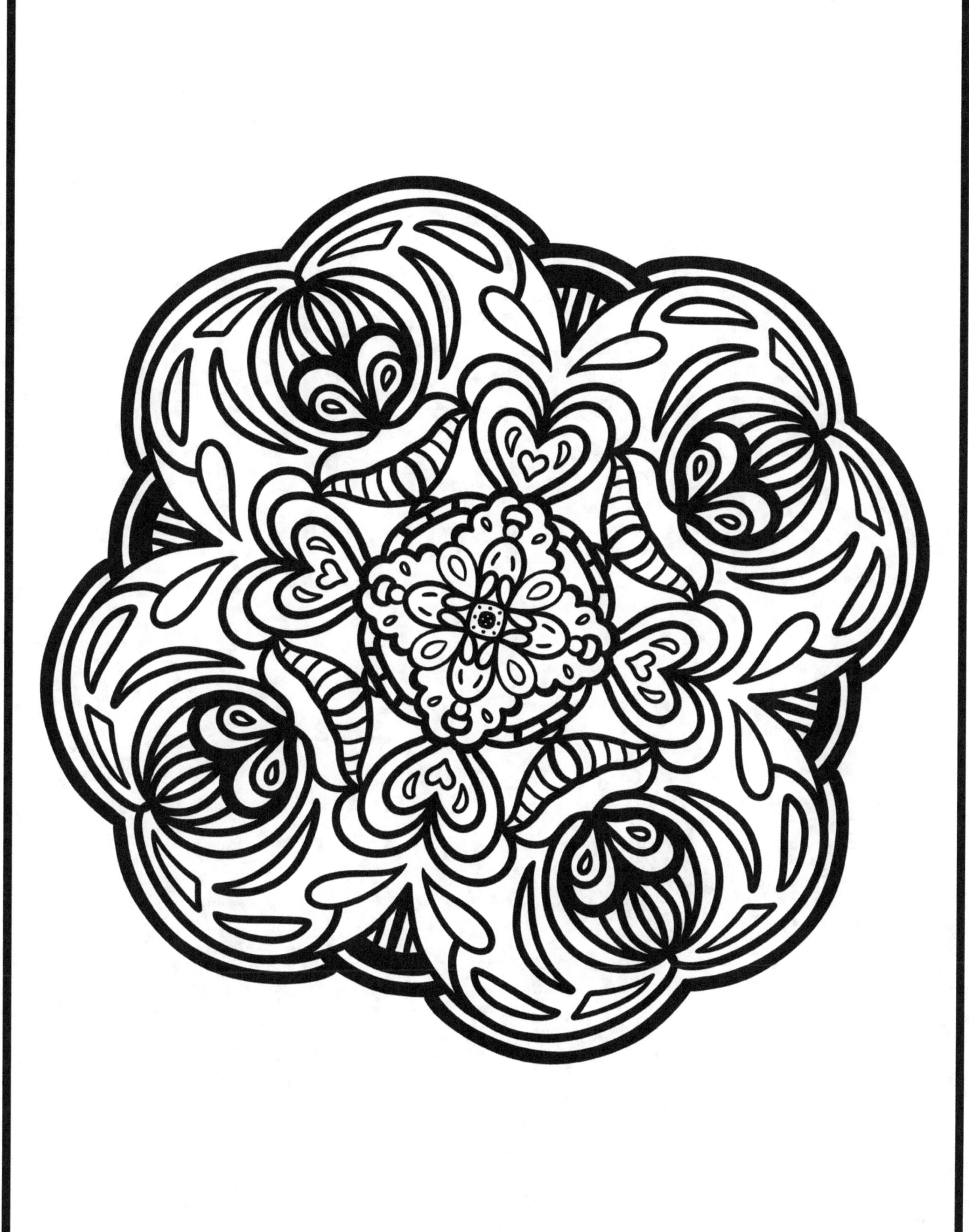

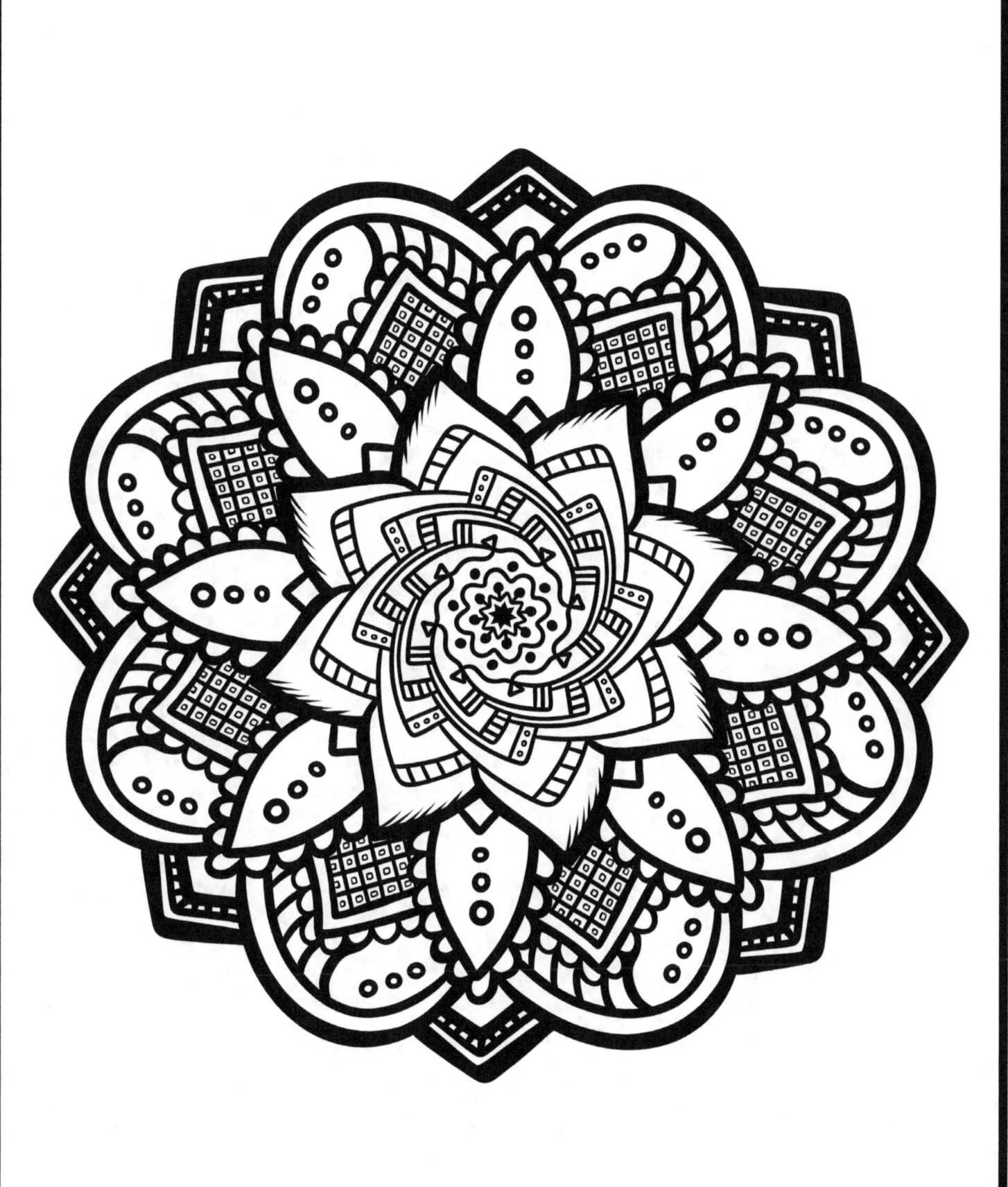

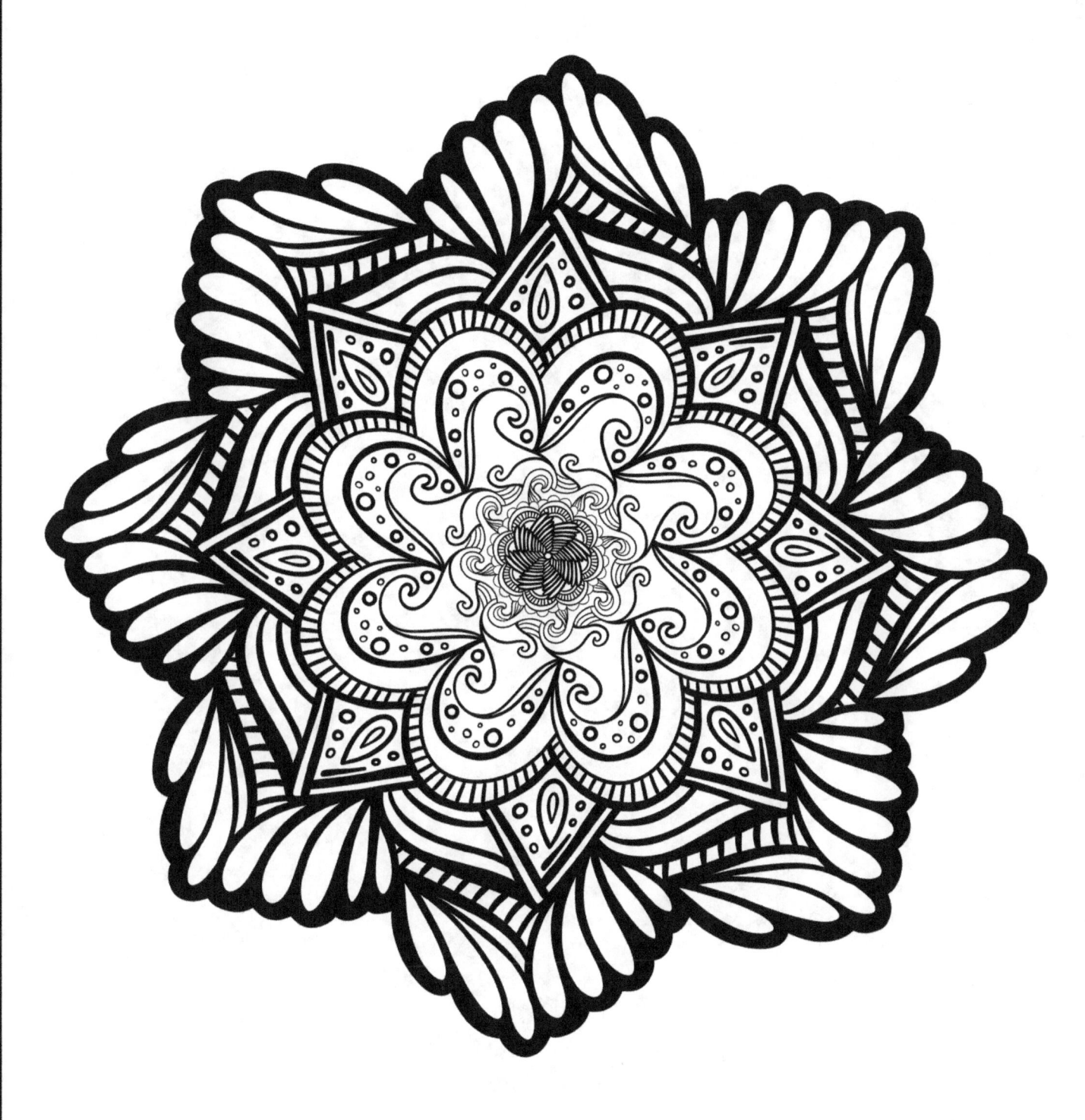

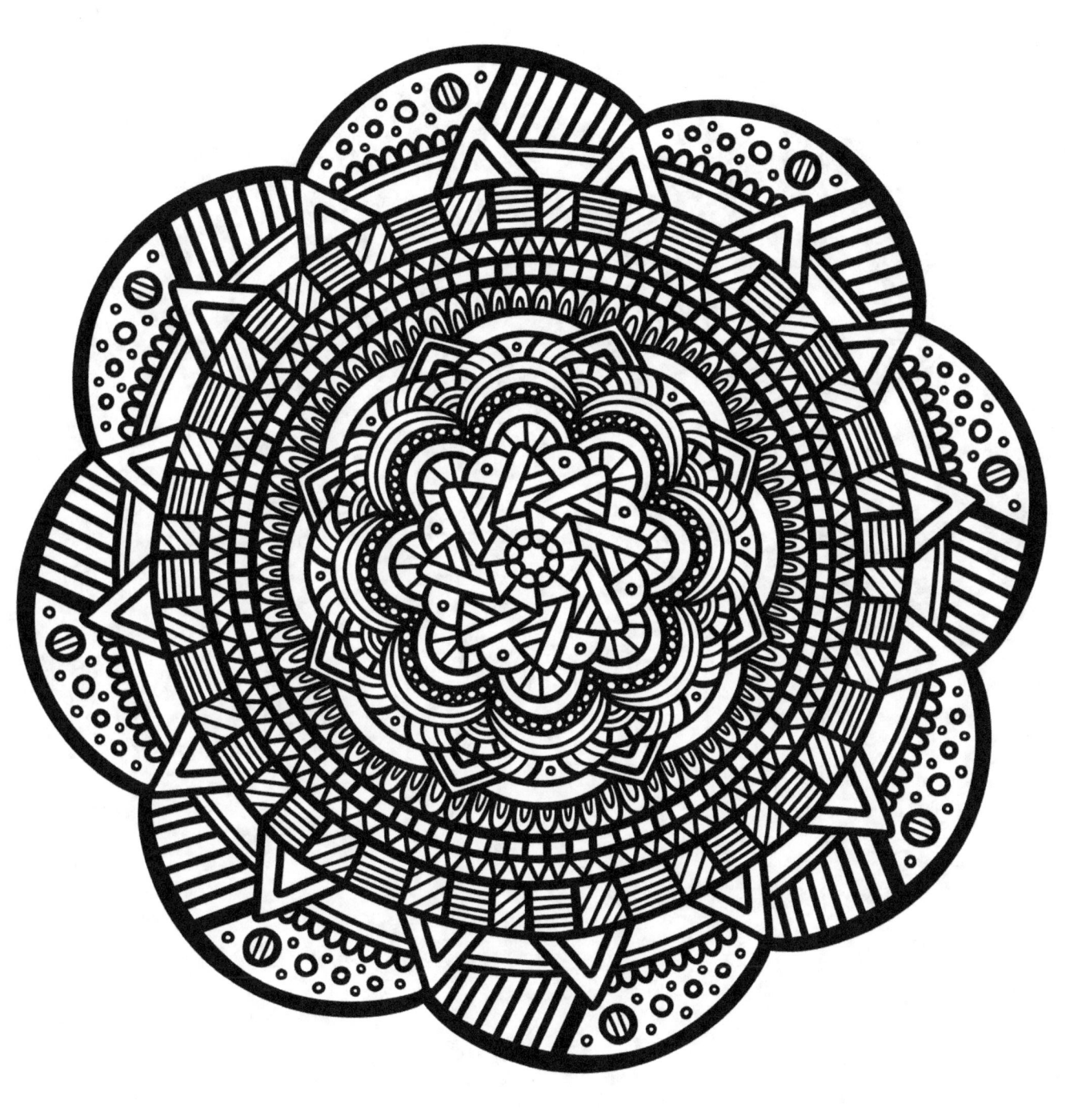

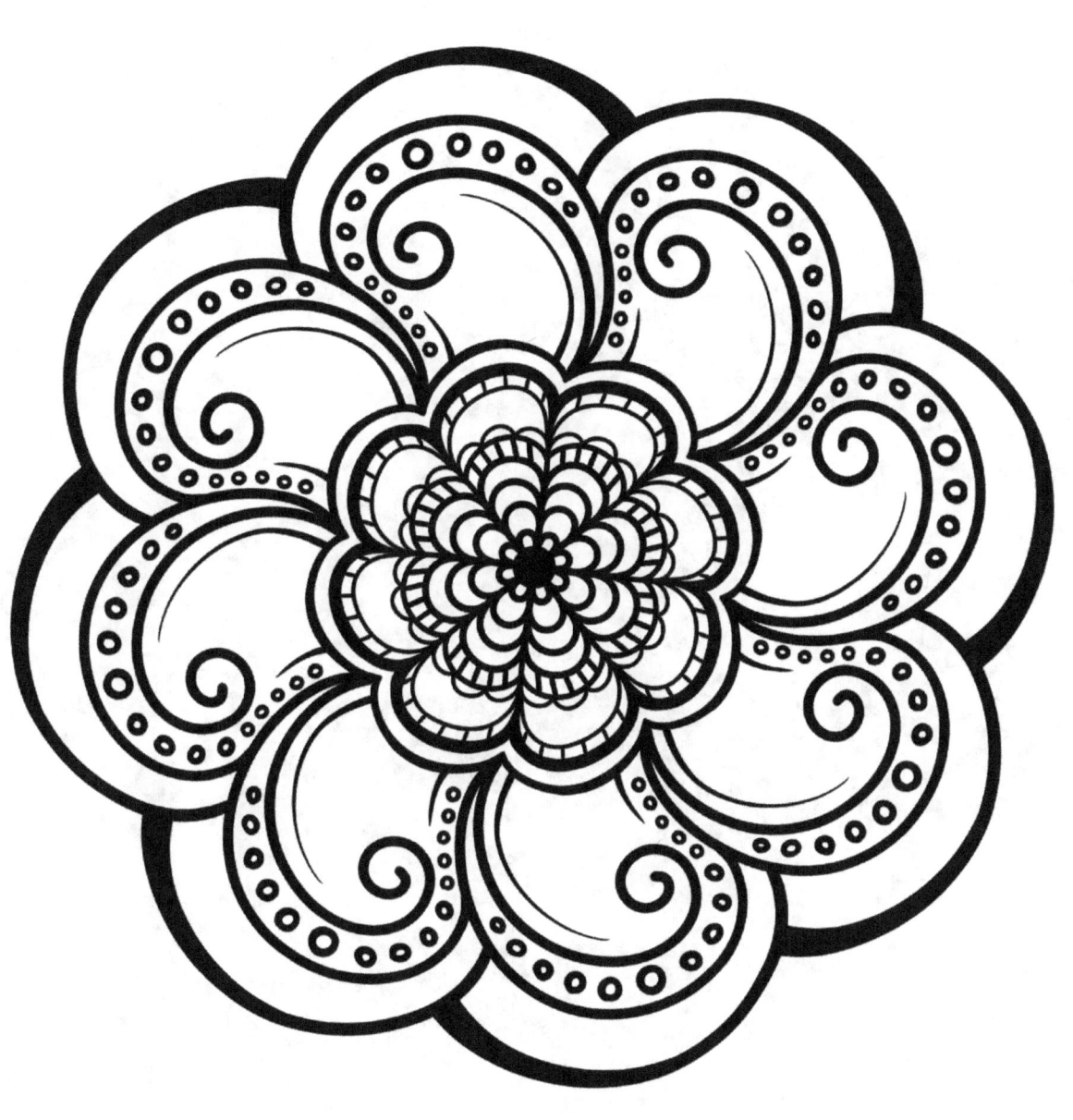

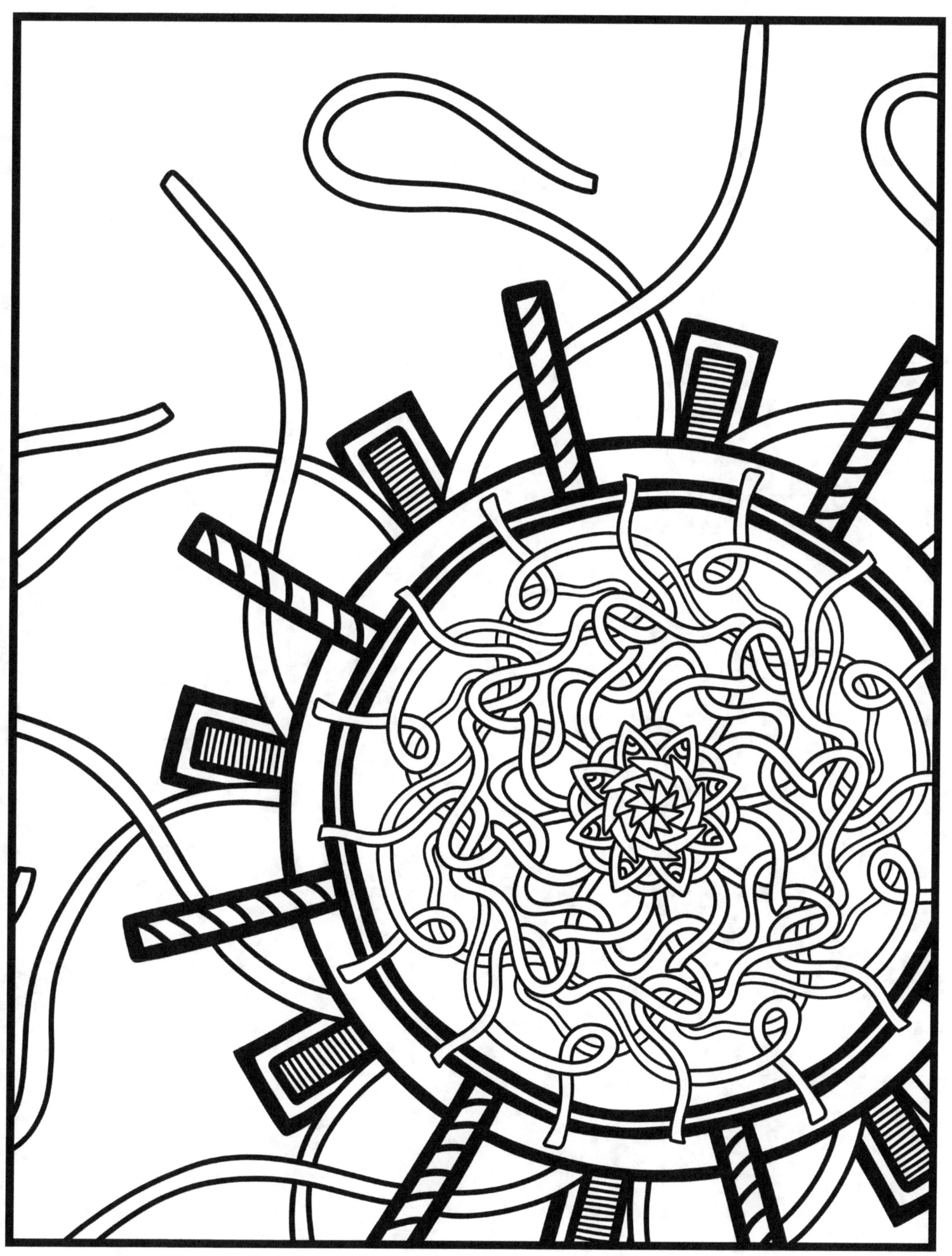

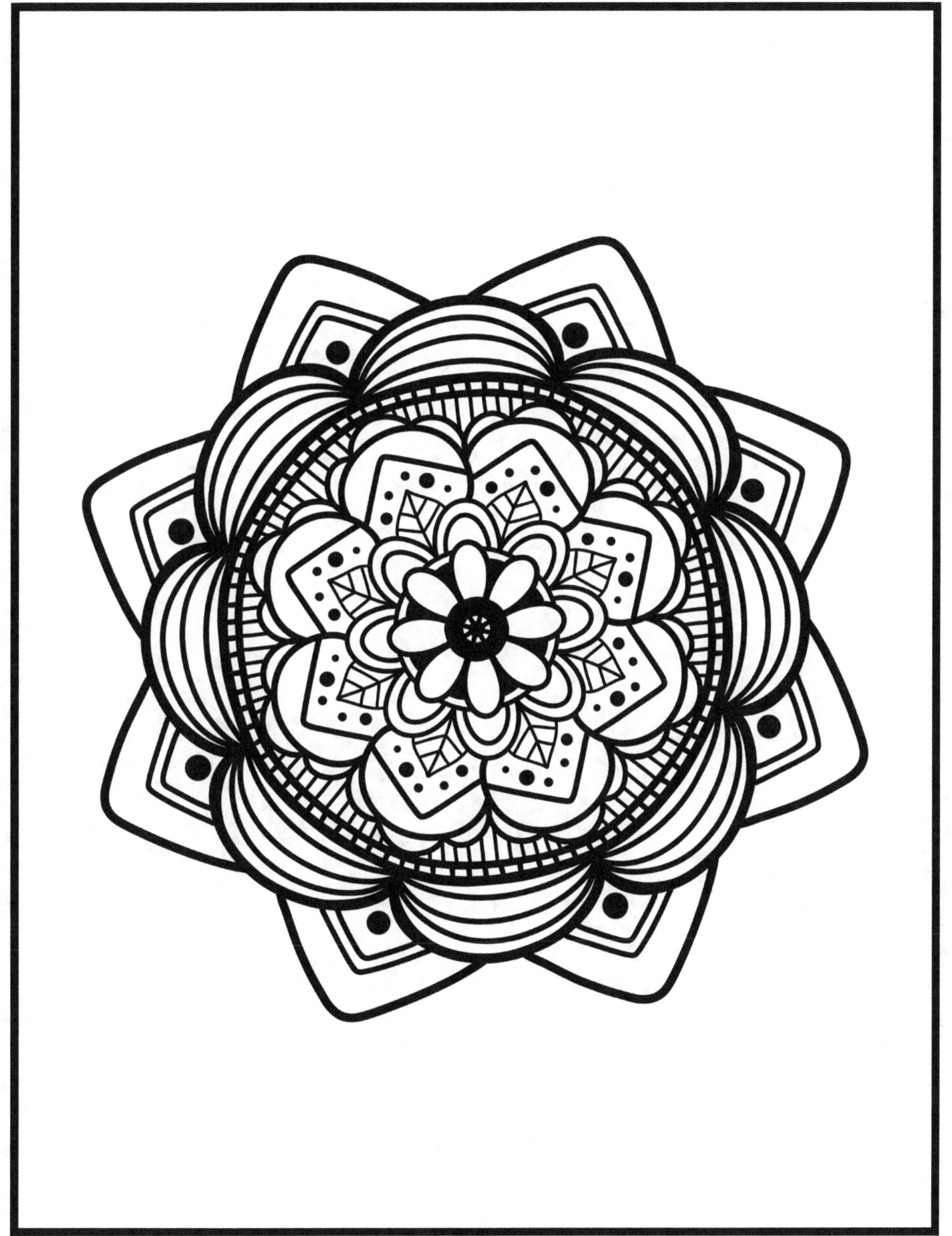

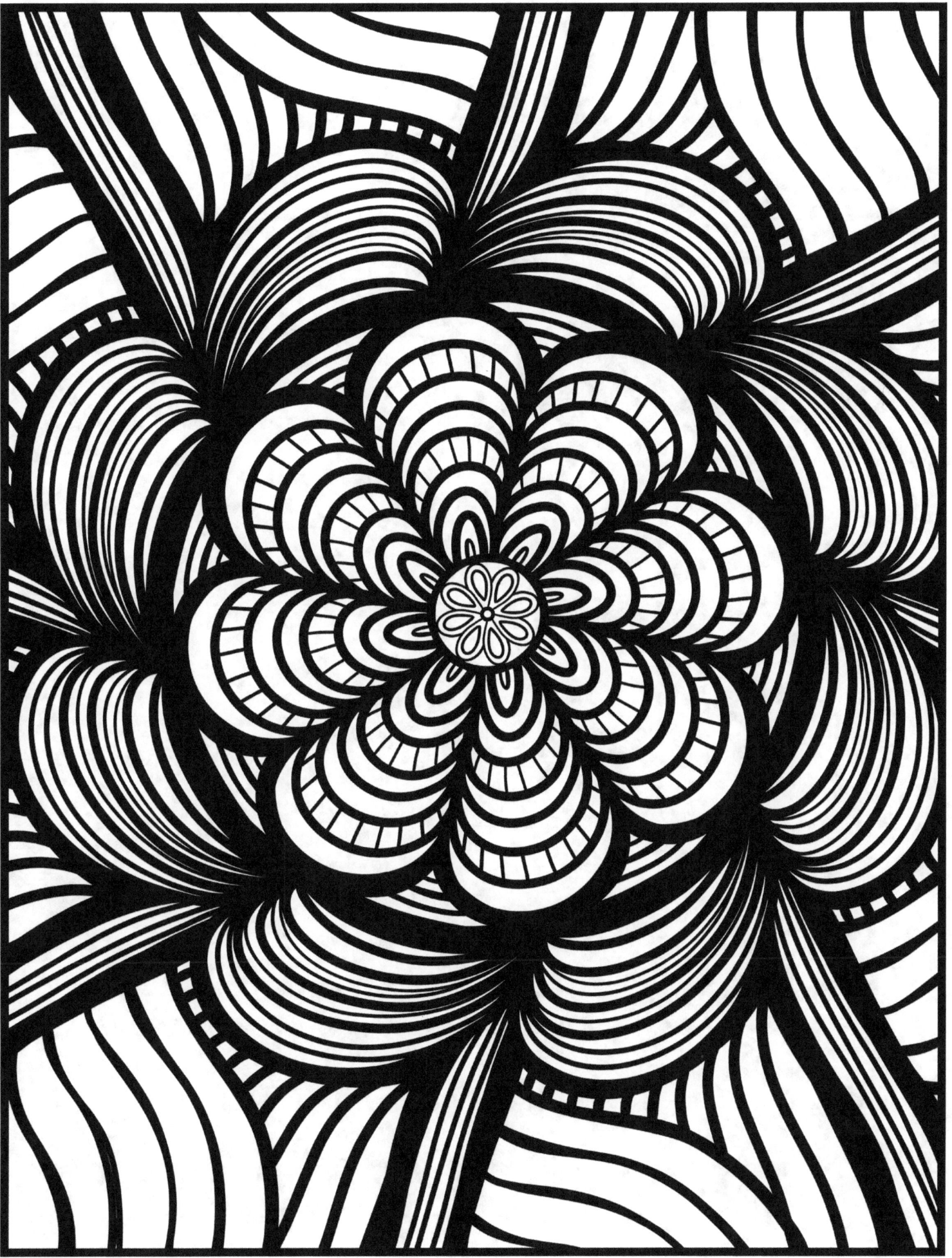

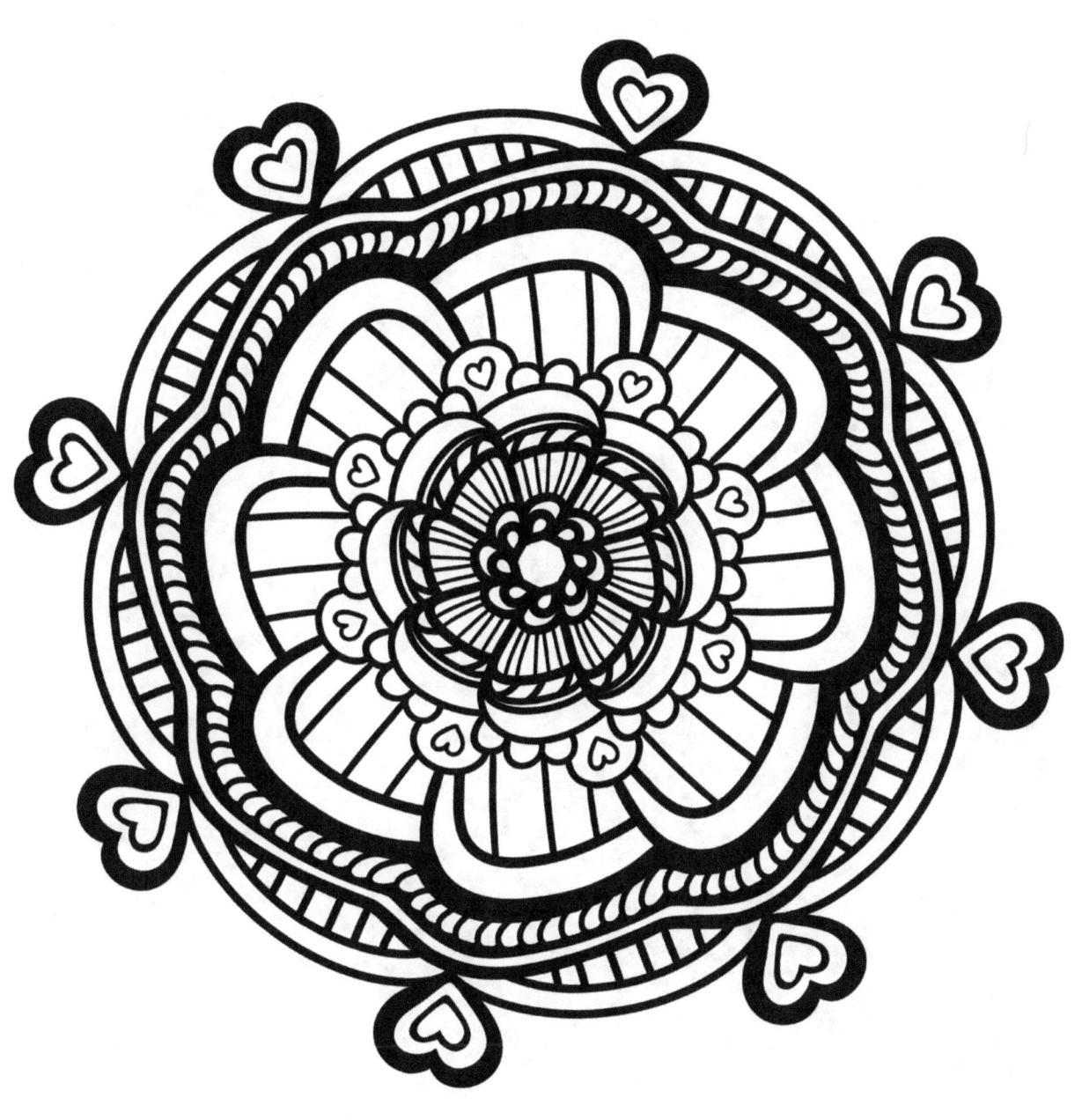

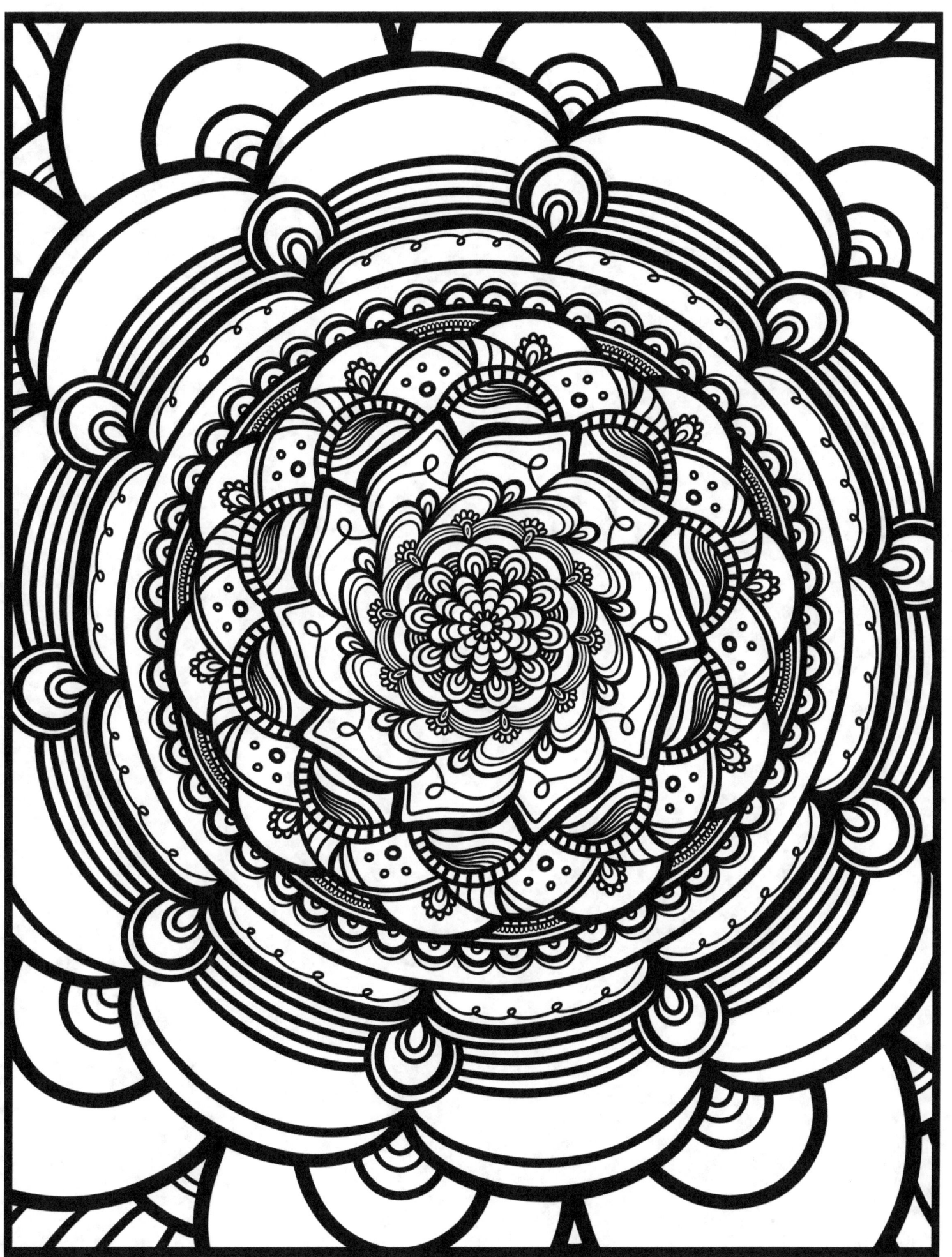

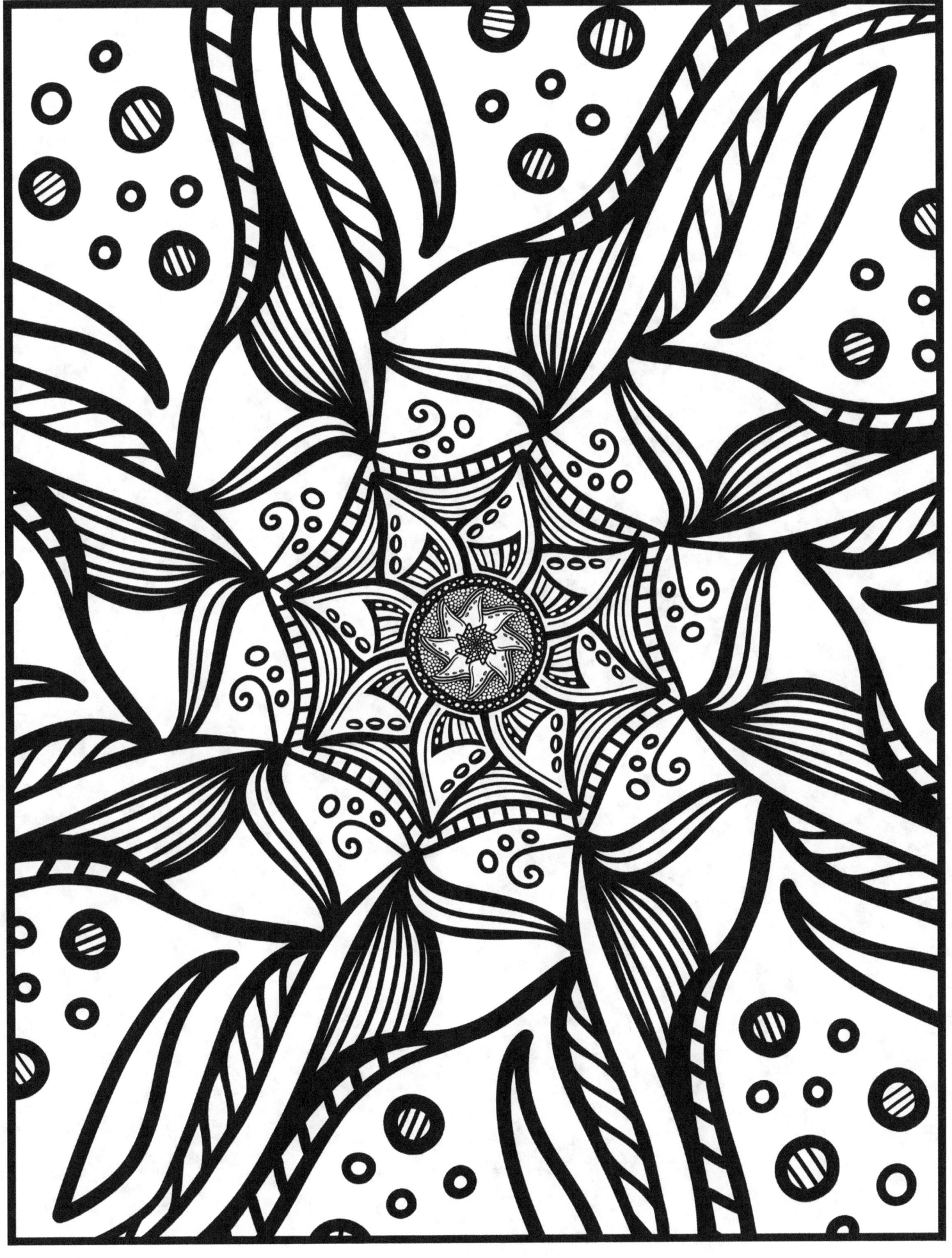

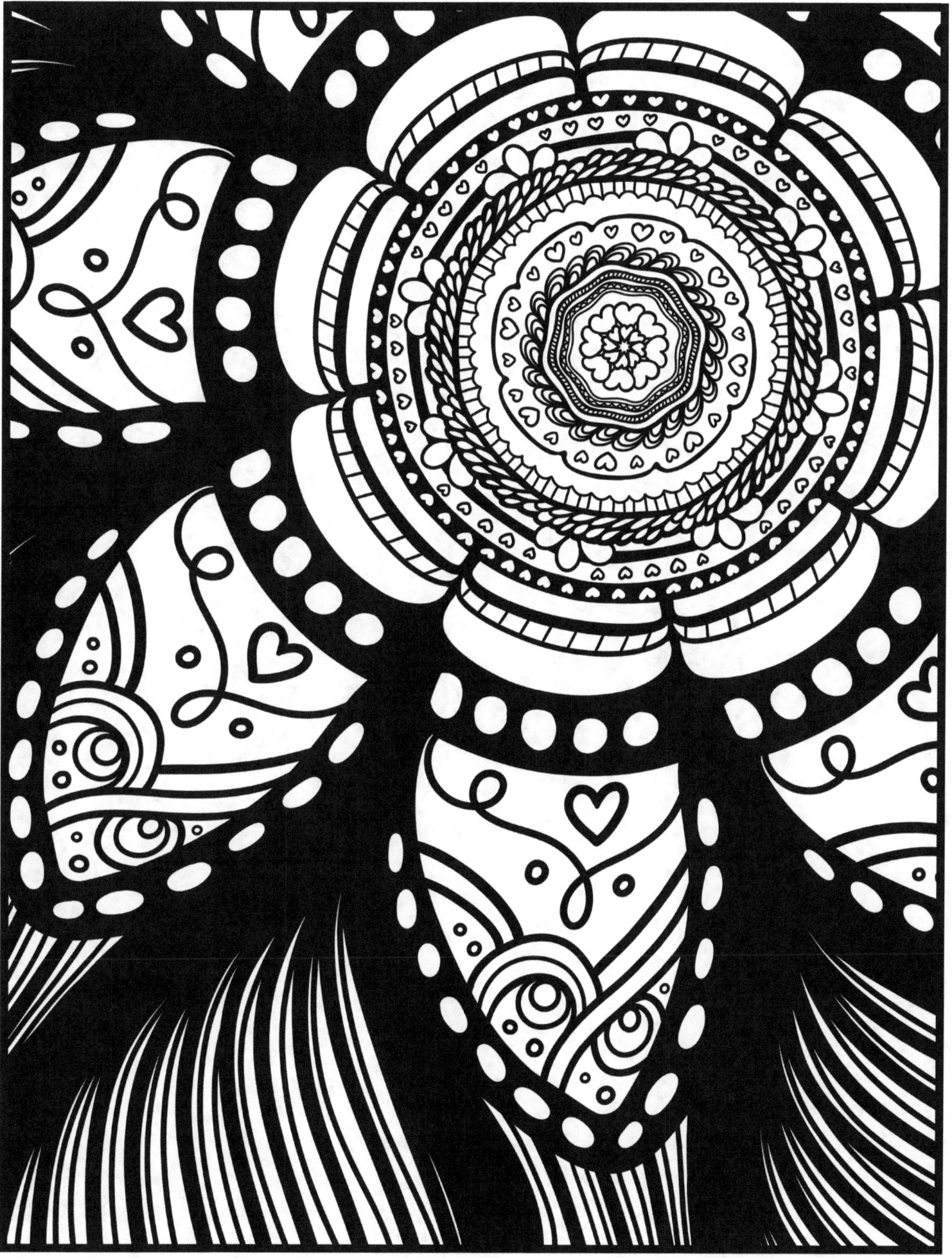

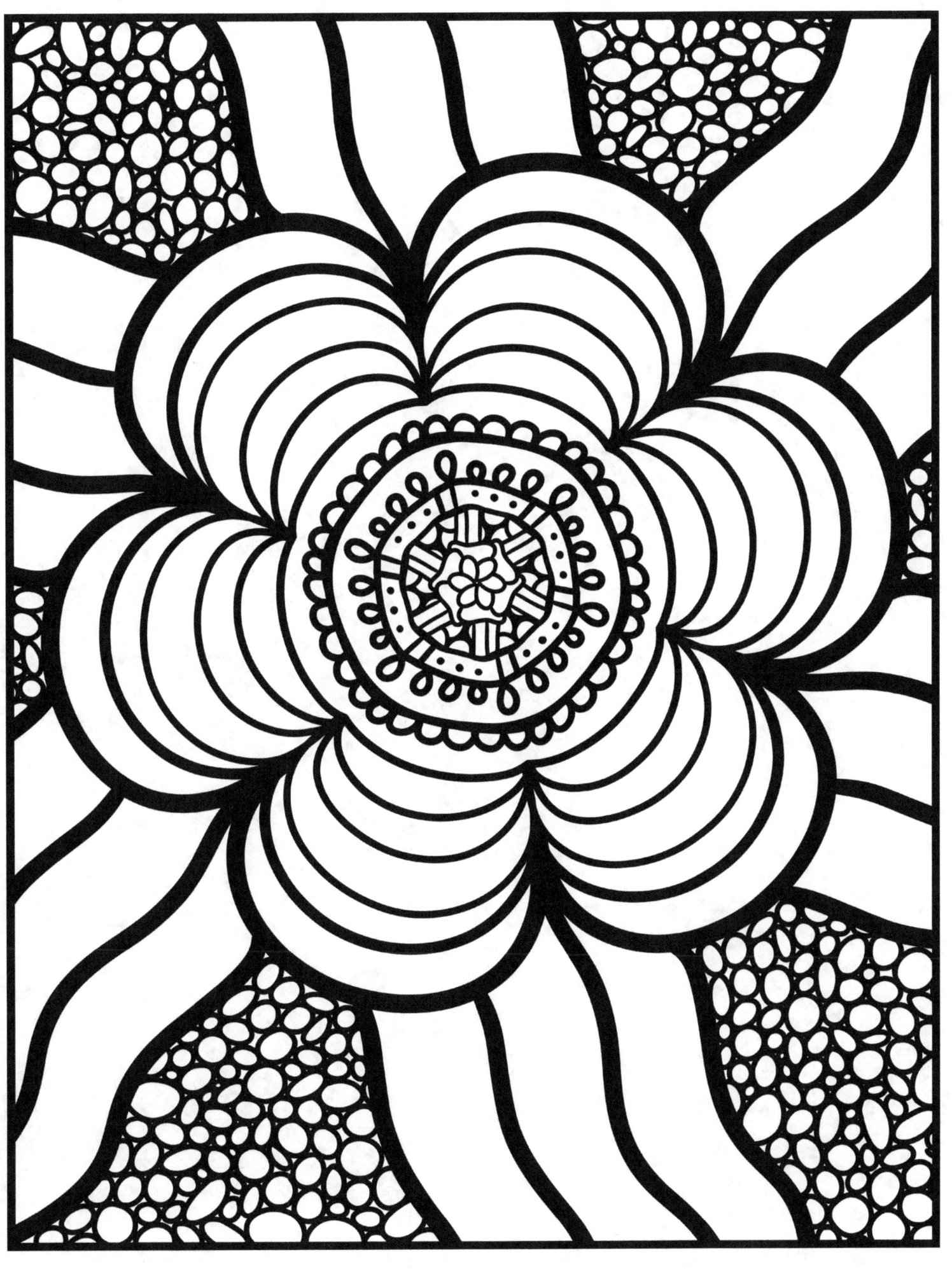

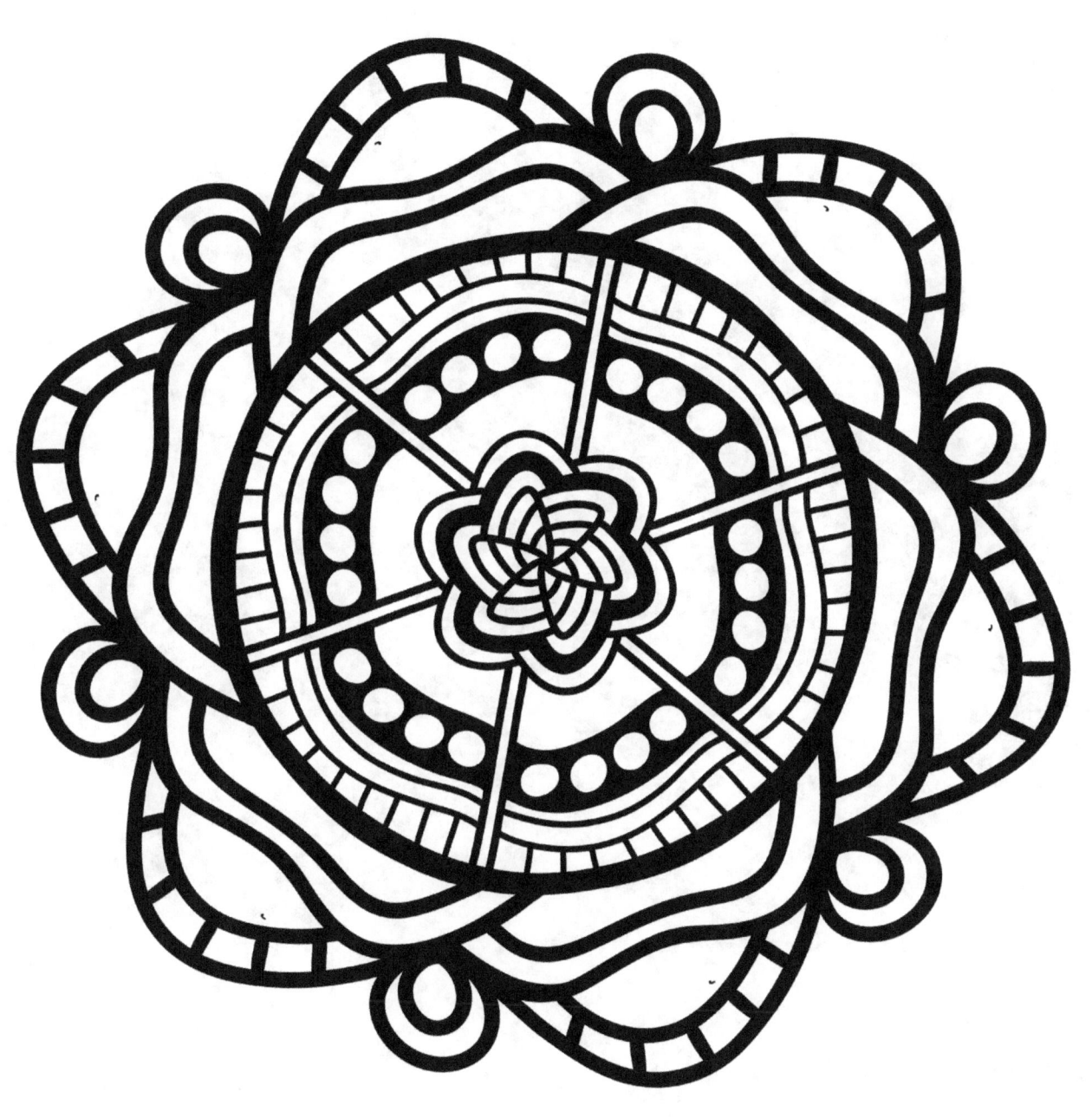

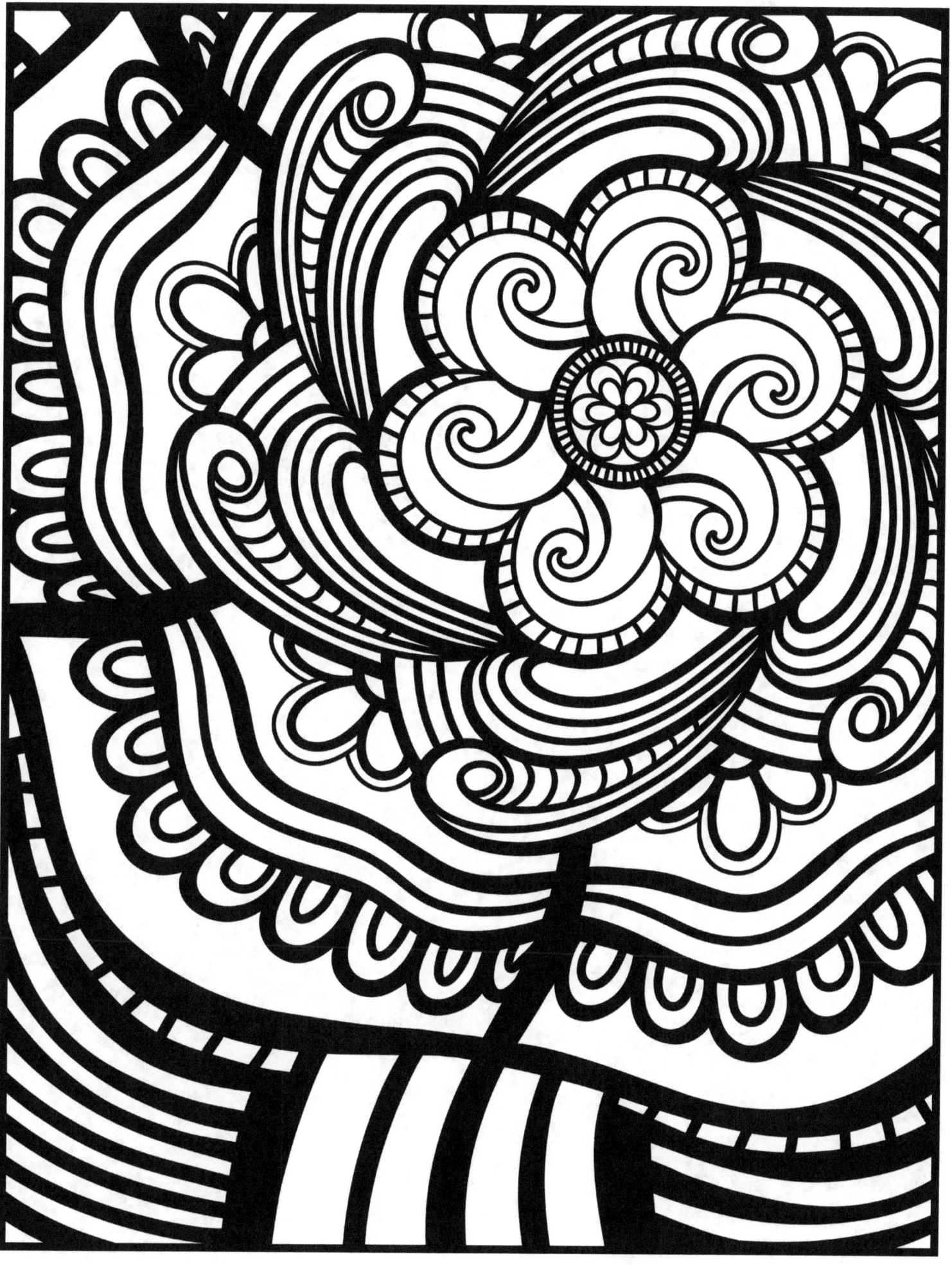

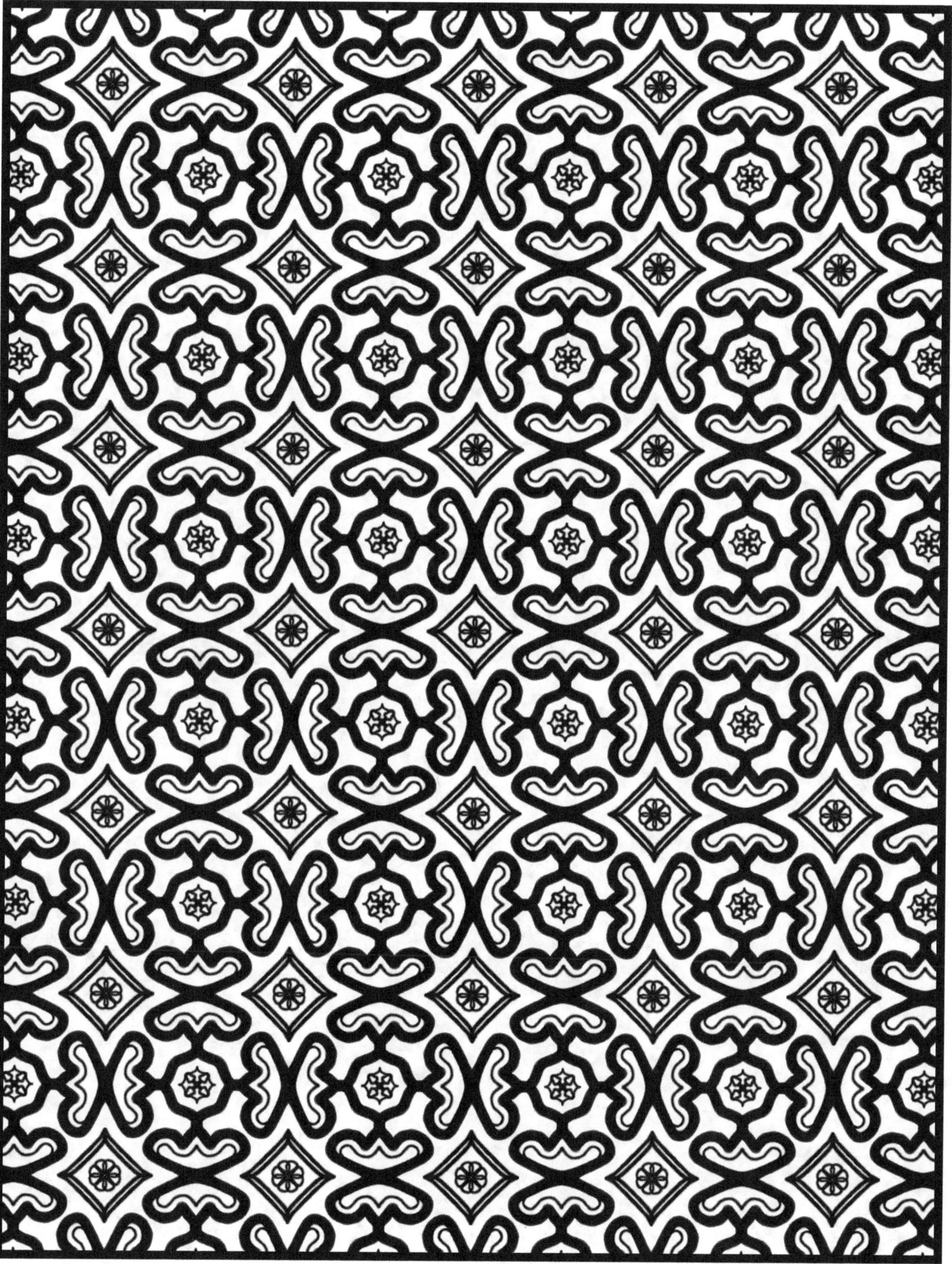

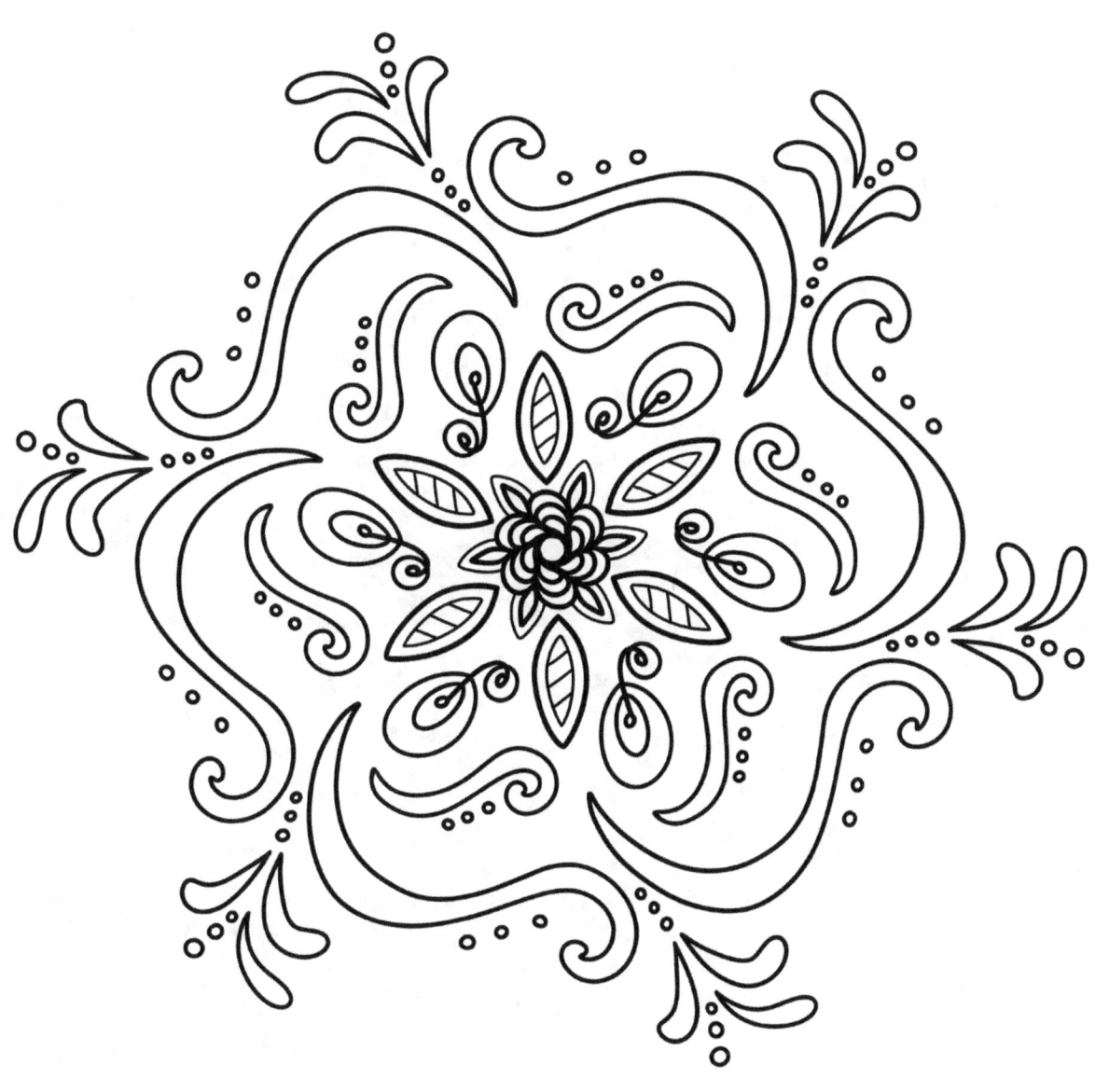

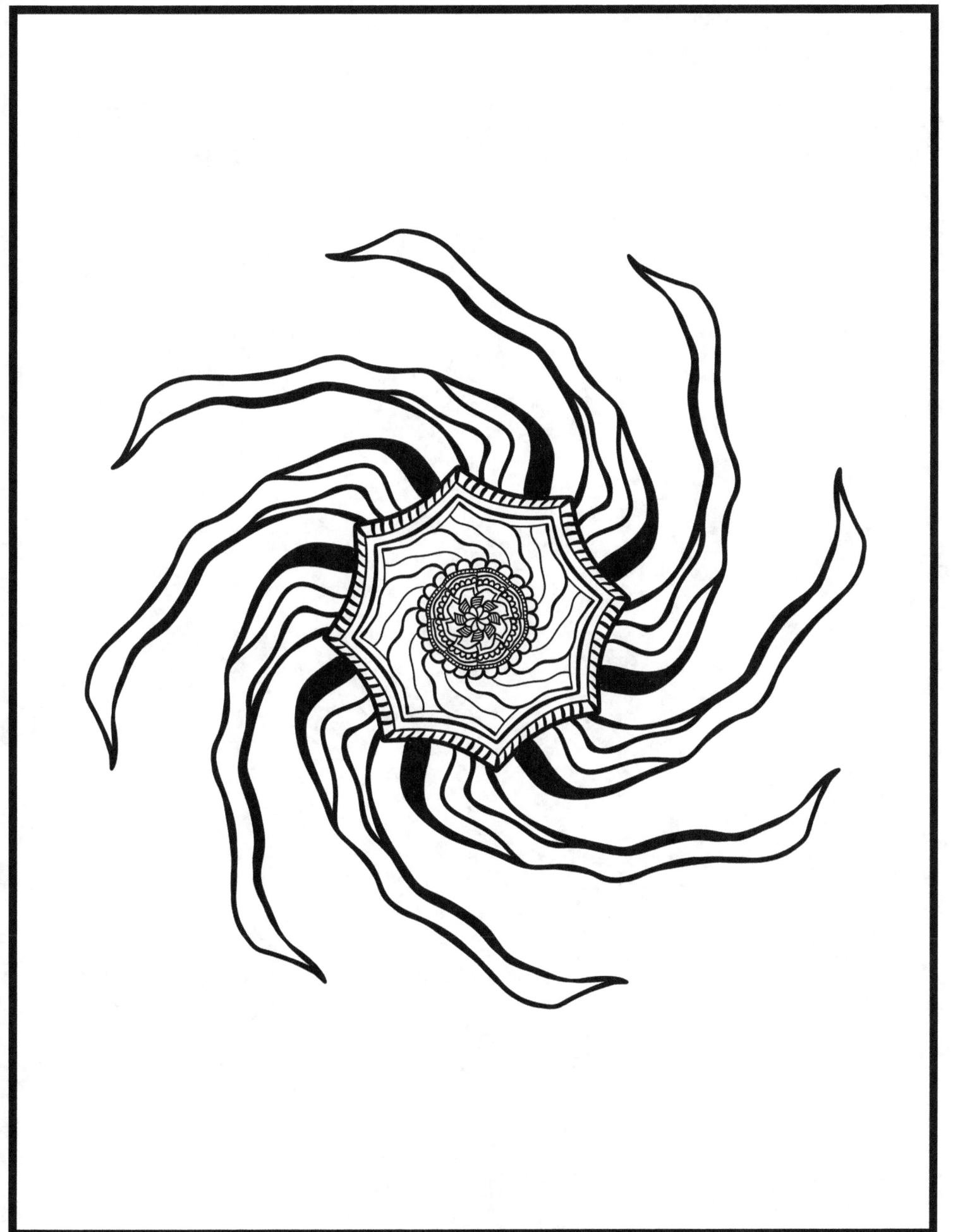

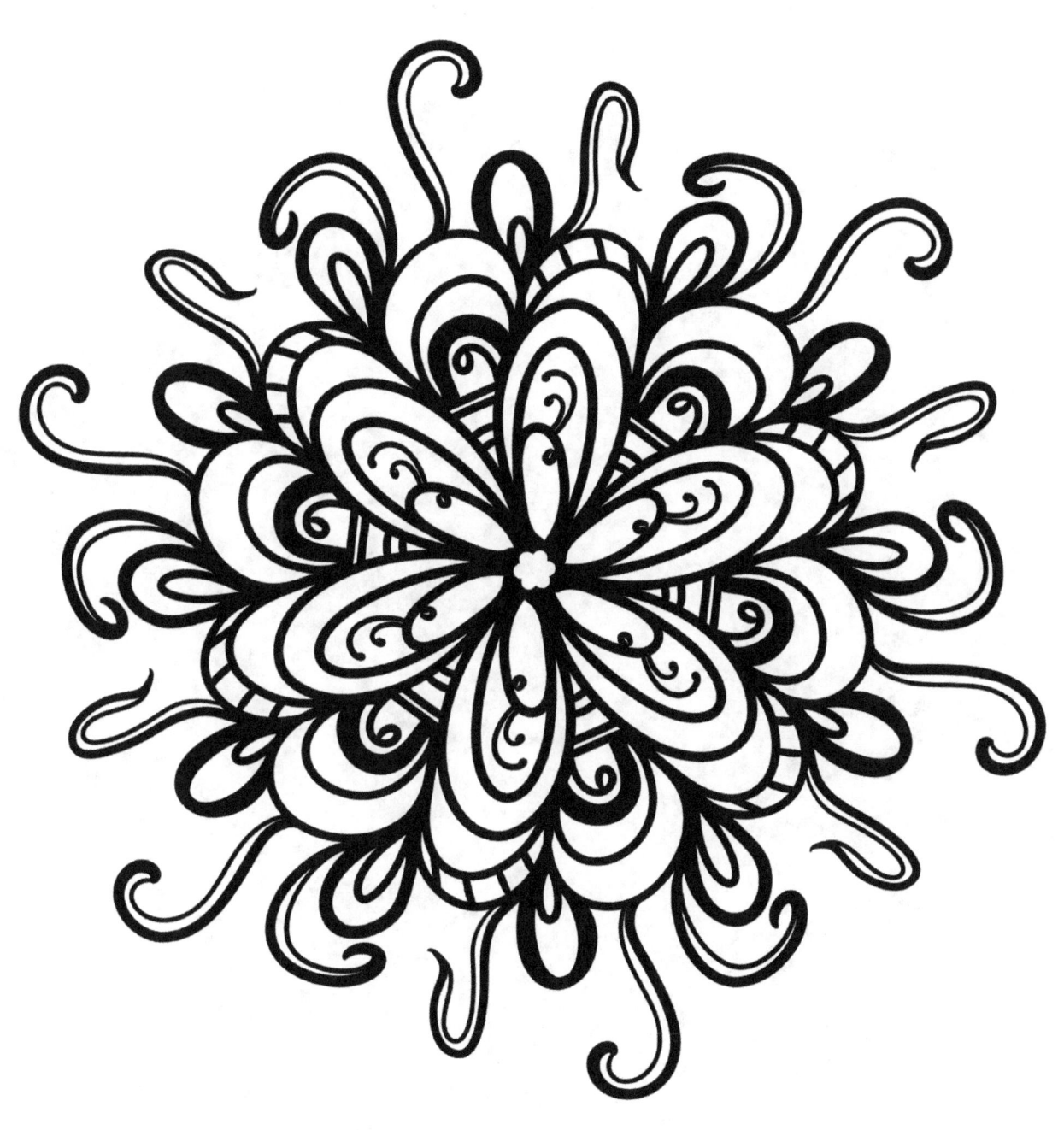

More coloring books by Karalyn Rose...

www.karalynrose.com

Find Karalyn Rose on Facebook. Share your coloring pages!
www.facebook.com/karalynrosebooks